GIORGIO VASARI

LIVES OF THREE RENAISSANCE ARTISTS

TRANSLATED BY GEORGE BULL

PENGUIN BOOKS

PENGUIN BOOKS

Published by the Penguin Group
Penguin Books Ltd, 27 Wrights Lane, London w8 5TZ, England
Penguin Books USA Inc., 375 Hudson Street, New York, New York 10014, USA
Penguin Books Australia Ltd, Ringwood, Victoria, Australia
Penguin Books Canada Ltd, 10 Alcorn Avenue, Toronto, Ontario, Canada M4V 3B2
Penguin Books (NZ) Ltd, 182–190 Wairau Road, Auckland 10, New Zealand

Penguin Books Ltd, Registered Offices: Harmondsworth, Middlesex, England

This translation first published in Lives of the Artists 1965
Reprinted as Lives of the Artists: Volume I 1987
This edition published 1995
I 3 5 7 9 10 8 6 4 2

Copyright © George Bull, 1965 All rights reserved

Filmset by Datix International Limited, Bungay, Suffolk Printed in England by Clays Ltd, St Ives plc

Except in the United States of America, this book is sold subject to the condition that it shall not, by way of trade or otherwise, be lent, re-sold, hired out, or otherwise circulated without the publisher's prior consent in any form of binding or cover other than that in which it is published and without a similar condition including this condition being imposed on the subsequent purchaser

CONTENTS

Leonardo da Vinci 1 Raphael 20 Michelangelo 40

Life of Leonardo da Vinci

FLORENTINE PAINTER AND SCULPTOR, 1452-1519

In the normal course of events many men and women are born with various remarkable qualities and talents; but occasionally, in a way that transcends nature, a single person is marvellously endowed by heaven with beauty, grace, and talent in such abundance that he leaves other men far behind, all his actions seem inspired, and indeed everything he does clearly comes from God rather than from human art.

Everyone acknowledged that this was true of Leonardo da Vinci, an artist of outstanding physical beauty who displayed infinite grace in everything he did and who cultivated his genius so brilliantly that all problems he studied he solved with ease. He possessed great strength and dexterity; he was a man of regal spirit and tremendous breadth of mind; and his name became so famous that not only was he esteemed during his lifetime but his reputation endured and became even greater after his death.

This marvellous and divinely inspired Leonardo was the son of Piero da Vinci. He would have been very proficient at his early lessons if he had not been so volatile and unstable; for he was always setting himself to learn many things only to abandon them almost immediately. Thus he began to learn arithmetic, and after a few months he had made so much progress that he used to baffle his master with the questions and problems that he raised. For a little while he attended

to music, and then he very soon resolved to learn to play the lyre, for he was naturally of an elevated and refined disposition; and with this instrument he accompanied his own charming improvised singing. All the same, for all his other enterprises Leonardo never ceased drawing and working in relief, pursuits which best suited his temperament.

Realizing this, and considering the quality of his son's intelligence, Piero one day took some of Leonardo's drawings along to Andrea del Verrocchio (who was a close friend of his) and earnestly begged him to say whether it would be profitable for the boy to study design.1 Andrea was amazed to see what extraordinary beginnings Leonardo had made and he urged Piero to make him study the subject. So Piero arranged for Leonardo to enter Andrea's workshop. The boy was delighted with this decision; and he began to practise not only one branch of the arts but all the branches in which design plays a part. He was marvellously gifted, and he proved himself to be a first-class geometrician in his work as a sculptor and architect. In his youth Leonardo made in clay several heads of women, with smiling faces, of which plaster casts are still being made, as well as some children's heads executed as if by a mature artist. He also did many architectural drawings both of ground plans and of other elevations, and, while still young, he was the first to propose reducing the Arno to a navigable canal between Pisa and Florence. He made designs for mills, fulling machines, and engines that could be driven by water-power; and as he intended to be a

^{1.} Andrea del Verrocchio, painter and goldsmith, and the chief sculptor in Florence after Donatello's death.

painter by profession he carefully studied drawing from life. Sometimes he made clay models, draping the figures with rags dipped in plaster, and then drawing them painstakingly on fine Rheims cloth or prepared linen. These drawings were done in black and white with the point of the brush, and the results were marvellous, as one can see from the examples I have in my book of drawings. Besides this, Leonardo did beautiful and detailed drawings on paper which are unrivalled for the perfection of their finish. (I have an example of these in a superb head in coloured silverpoint.) Altogether, his genius was so wonderfully inspired by the grace of God, his powers of expression were so powerfully fed by a willing memory and intellect, and his writing conveyed his ideas so precisely, that his arguments and reasonings confounded the most formidable critics. In addition, he used to make models and plans showing how to excavate and tunnel through mountains without difficulty, so as to pass from one level to another; and he demonstrated how to lift and draw great weights by means of levers, hoists, and winches, and ways of cleansing harbours and using pumps to suck up water from great depths. His brain was always busy on such devices, and one can find drawings of his ideas and experiments scattered among our craftsmen today; I myself have seen many of them. He also spent a great deal of time in making a pattern of a series of knots, so arranged that the connecting thread can be traced from one end to the other and the complete design fills a round space. There exists a splendid engraving of one of these fine and intricate designs, with these words in the centre: Leonardus Vinci Academia.

Among his models and plans there was one which Leonardo

would often put before the citizens who were then governing Florence – many of them men of great discernment – showing how he proposed to raise and place steps under the church of San Giovanni without damaging the fabric. His arguments were so cogent that they would allow themselves to be convinced, although when they all went their several ways each of them would realize the impossibility of what Leonardo suggested.

Leonardo's disposition was so lovable that he commanded everyone's affection. He owned, one might say, nothing and he worked very little, yet he always kept servants as well as horses. These gave him great pleasure as indeed did all the animal creation which he treated with wonderful love and patience. For example, often when he was walking past the places where birds were sold he would pay the price asked, take them from their cages, and let them fly off into the air, giving them back their lost freedom. In return he was so favoured by nature that to whatever he turned his mind or thoughts the results were always inspired and perfect; and his lively and delightful works were incomparably graceful and realistic.

Clearly, it was because of his profound knowledge of painting that Leonardo started so many things without finishing them; for he was convinced that his hands, for all their skill, could never perfectly express the subtle and wonderful ideas of his imagination. Among his many interests was included the study of nature; he investigated the properties of plants and then observed the motion of the heavens, the path of the moon, and the course of the sun.

I mentioned earlier that when he was still young Leonardo entered the workshop of Andrea del Verrocchio. Now at that

time Verrocchio was working on a panel picture showing the Baptism of Christ by St John, for which Leonardo painted an angel who was holding some garments; and despite his youth, he executed it in such a manner that his angel was far better than the figures painted by Andrea. This was the reason why Andrea would never touch colours again, he was so ashamed that a boy understood their use better than he did.

The story goes that once when Piero da Vinci was at his house in the country one of the peasants on his farm, who had made himself a buckler out of a fig tree that he had cut down, asked him as a favour to have it painted for him in Florence. Piero was very happy to do this, since the man was very adept at snaring birds and fishing and Piero himself very often made use of him in these pursuits. He took the buckler to Florence, and without saving a word about whom it belonged to he asked Leonardo to paint something on it. Some days later Leonardo examined the buckler, and, finding that it was warped, badly made, and clumsy, he straightened it in the fire and then gave it to a turner who, from the rough and clumsy thing that it was, made it smooth and even. Then having given it a coat of gesso and prepared it in his own way Leonardo started to think what he could paint on it so as to terrify anyone who saw it and produce the same effect as the head of Medusa. To do what he wanted Leonardo carried into a room of his own, which no one ever entered except himself, a number of green and other kinds of lizards, crickets. serpents, butterflies, locusts, bats, and various strange creatures of this nature; from all these he took and assembled different parts to create a fearsome and horrible monster which emitted a poisonous breath and turned the air to fire. He depicted the creature emerging from the dark cleft of a rock, belching forth venom from its open throat, fire from its eyes and smoke from its nostrils in so macabre a fashion that the effect was altogether monstrous and horrible. Leonardo took so long over the work that the stench of the dead animals in his room became unbearable, although he himself failed to notice because of his great love of painting. By the time he had finished the painting both the peasant and his father had stopped inquiring after it; but all the same he told his father that he could send for the buckler when convenient, since his work on it was completed. So one morning Piero went along to the room in order to get the buckler, knocked at the door, and was told by Leonardo to wait for a moment. Leonardo went back into the room, put the buckler on an easel in the light, and shaded the window; then he asked Piero to come in and see it. When his eyes fell on it Piero was completely taken by surprise and gave a sudden start, not realizing that he was looking at the buckler and that the form he saw was, in fact, painted on it. As he backed away, Leonardo checked him and said:

'This work certainly serves its purpose. It has produced the right reaction, so now you can take it away.'

Piero thought the painting was indescribably marvellous and he was loud in praise of Leonardo's ingenuity. And then on the quiet he bought from a pedlar another buckler, decorated with a heart pierced by a dart, and he gave this to the peasant, who remained grateful to him for the rest of his days. Later on Piero secretly sold Leonardo's buckler to some merchants in Florence for a hundred ducats; and not long afterwards it came into the hands of the duke of Milan, who paid those merchants three hundred ducats for it.

Leonardo then painted a Madonna, a very fine work which came into the possession of Pope Clement VII; one of the details in this picture was a vase of water containing some flowers, painted with wonderful realism, which had on them dewdrops that looked more convincing than the real thing.

Leonardo then took it in mind to do a painting in oils showing the head of Medusa attired with a coil of serpents, the strangest and most extravagant invention imaginable. But this was a work that needed time, and so as with most of the things he did it was never finished. Today it is kept among the fine works of art in the palace of Duke Cosimo, along with the head of an angel raising one arm, which is foreshortened as it comes forward from the shoulder to the elbow, and lifting a hand to its breast with the other.

One of the remarkable aspects of Leonardo's talent was the extremes he went to, in his anxiety to achieve solidity of modelling, in the use of inky shadows. Thus to get the darkest possible grounds Leonardo selected blacks that made deeper shadows and were indeed blacker than any other, endeavouring to make his lights all the brighter by contrast. However, he eventually succeeded so well that his paintings were wholly devoid of light and the subjects looked as if they were being seen by night rather than clearly defined by daylight. All this came from his striving to obtain ever more relief and to bring his art to absolute perfection. I must mention another habit of Leonardo's: he was always fascinated when he saw a man of striking appearance, with a strange head of hair or beard; and anyone who attracted him he would follow about all day long and end up seeing so clearly in his mind's eye that when he got home he could draw him as if he were standing there in the flesh. There are many drawings of both male and female heads which he did in this way, and I have several examples of them in the book of drawings mentioned so often before, such as the sketch of Amerigo Vespucci, which shows the head of a very handsome old man drawn in charcoal, or of Scaramuccia, the leader of the gipsies, which Giambullari subsequently left to Donato Valdambrini of Arezzo, canon of San Lorenzo.

Leonardo also started work on a panel picture showing the Adoration of the Magi and containing a number of beautiful details, especially the heads; this painting, however, which was in the house of Amerigo Benci, opposite the Loggia de' Peruzzi, like so many of his works remained unfinished.

Meanwhile, in Milan, following the death of Duke Gian Galeazzo, Ludovico Sforza took over the state (in the year 1494) and did Leonardo the honour of inviting him to visit Milan so that he could hear him play the lyre, an instrument of which the new duke was very fond. Leonardo took with him a lyre that he had made himself, mostly of silver, in the shape of a horse's head (a very strange and novel design) so that the sound should be more sonorous and resonant. Leonardo's performance was therefore superior to that of all the other musicians who had come to Ludovico's court. Leonardo was also the most talented improviser in verse of his time. Moreover, he was a sparkling conversationalist, and after they had spoken together the duke developed almost boundless love and admiration for his talents. He begged Leonardo to paint

^{1.} Leonardo probably went to Milan in 1482, when Ludovico was already in control of the state.

for him an altarpiece containing a Nativity, which he then sent to the emperor.

Leonardo also executed in Milan, for the Dominicans of Santa Maria delle Grazie, a marvellous and beautiful painting of the Last Supper. Having depicted the heads of the apostles full of splendour and majesty, he deliberately left the head of Christ unfinished, convinced he would fail to give it the divine spirituality it demands. This all but finished work has ever since been held in the greatest veneration by the Milanese and others. In it Leonardo brilliantly succeeded in envisaging and reproducing the tormented anxiety of the apostles to know who had betrayed their master; so in their faces one can read the emotions of love, dismay, and anger, or rather sorrow, at their failure to grasp the meaning of Christ. And this excites no less admiration than the contrasted spectacle of the obstinacy, hatred, and treachery in the face of Judas or, indeed, than the incredible diligence with which every detail of the work was executed. The texture of the very cloth on the table is counterfeited so cunningly that the linen itself could not look more realistic.

It is said that the prior used to keep pressing Leonardo, in the most importunate way, to hurry up and finish the work, because he was puzzled by Leonardo's habit of sometimes spending half a day at a time contemplating what he had done so far; if the prior had had his way, Leonardo would have toiled like one of the labourers hoeing in the garden and never put his brush down for a moment. Not satisfied with this, the prior then complained to the duke, making such a fuss that the duke was constrained to send for Leonardo and, very tactfully, question him about the painting, although he showed

perfectly well that he was only doing so because of the prior's insistence. Leonardo, knowing he was dealing with a prince of acute and discerning intelligence, was willing (as he never had been with the prior) to explain his mind at length; and so he talked to the duke for a long time about the art of painting. He explained that men of genius sometimes accomplish most when they work the least; for, he added, they are thinking out inventions and forming in their minds the perfect ideas which they subsequently express and reproduce with their hands. Leonardo then said that he still had two heads to paint: the head of Christ was one, and for this he was unwilling to look for any human model, nor did he dare suppose that his imagination could conceive the beauty and divine grace that properly belonged to the incarnate Deity. Then, he said, he had yet to do the head of Judas, and this troubled him since he did not think he could imagine the features that would form the countenance of a man who, despite all the blessings he had been given, could so cruelly steel his will to betray his own master and the creator of the world. However, added Leonardo, he would try to find a model for Judas, and if he did not succeed in doing so, why then he was not without the head of that tactless and importunate prior. The duke roared with laughter at this and said that Leonardo had every reason in the world for saying so. The unfortunate prior retired in confusion to worry the labourers working in his garden, and he left off worrying Leonardo, who skilfully finished the head of Judas and made it seem the very embodiment of treachery and inhumanity. The head of Christ remained, as was said, unfinished

This noble painting was so finely composed and executed

that the King of France subsequently wanted to remove it to his kingdom. He tried all he could to find architects to make cross-stays of wood and iron with which the painting could be protected and brought safely to France, without any regard for expense, so great was his desire to have it. But as the painting was done on a wall his majesty failed to have his way and it remained in the possession of the Milanese. While he was working on the Last Supper, in the same refectory where there is a painting of the Passion done in the old manner, on the end wall, Leonardo portrayed Ludovico himself with his eldest son, Massimiliano; and on the other side, with the Duchess Beatrice, his other son Francesco, both of whom later became dukes of Milan; and all these figures are beautifully painted.

While he was engaged on this work Leonardo proposed to the duke that he should make a huge equestrian statue in bronze as a memorial to his father; then he started and carried the work forward on such a scale that it was impossible to finish it. There have even been some to say (men's opinions are so various and, often enough, so envious and spiteful) that Leonardo had no intention of finishing it when he started. This was because it was so large that it proved an insoluble problem to cast it in one piece; and one can realize why, the outcome being what it was, many came to the conclusion they did, seeing that so many of his works remained unfinished. The truth, however, is surely that Leonardo's profound and discerning mind was so ambitious that this was itself an impediment; and the reason he failed was because he endeavoured to add excellence to excellence and perfection to perfection. As our Petrarch has said, the desire outran the

performance. In fact, those who saw the great clay model that Leonardo made considered that they had never seen a finer or more magnificent piece of work. It was preserved until the French came to Milan under King Louis and smashed it to pieces. Also lost is a little wax model which was held to be perfect, together with a reference book which Leonardo composed on the anatomy of horses. Leonardo then applied himself, even more assiduously, to the study of human anatomy, in which he collaborated with that excellent philosopher Marc Antonio della Torre, who was then lecturing at Pavia and who wrote on the subject. Della Torre, I have heard, was one of the first to illustrate the problems of medicine by the teachings of Galen and to throw true light on anatomy, which up to then had been obscured by the shadows of ignorance. In this he was wonderfully served by the intelligence, work, and hand of Leonardo, who composed a book annotated in pen and ink in which he did meticulous drawings in red chalk of bodies he had dissected himself. He showed all the bone structure. adding in order all the nerves and covering them with the muscles: the first attached to the skeleton, the second that hold it firm and the third that move it. In the various sections he wrote his observations in puzzling characters (written in reverse with the left hand) which cannot be deciphered by anyone who does not know the trick of reading them in a mirror.

Many of Leonardo's manuscripts on human anatomy are in the possession of Francesco Melzi, a Milanese gentleman who was a handsome boy when Leonardo was alive and who was greatly loved by him. Francesco cherishes and preserves these papers as relics of Leonardo, together with the portrait of that artist of such happy memory. Reading Leonardo's writings one is astonished at the brilliant way in which this inspired artist discussed so thoroughly art and anatomy (the muscles, nerves, and veins) and indeed every kind of subject.

Then Leonardo went back to Florence where he found that the Servite friars had commissioned Filippino to paint the altarpiece for the high altar of the Annunziata. Leonardo remarked that he would gladly have undertaken the work himself, and when he heard this, like the good-hearted person he was, Filippino decided to withdraw. Then the friars, to secure Leonardo's services, took him into their house and met all his expenses and those of his household. He kept them waiting a long time without even starting anything, and then finally he did a cartoon showing Our Lady with St Anne and the Infant Christ. This work not only won the astonished admiration of all the artists but when finished for two days it attracted to the room where it was exhibited a crowd of men and women. young and old, who flocked there, as if they were attending a great festival, to gaze in amazement at the marvels he had created. For in the face of Our Lady are seen all the simplicity and loveliness and grace that can be conferred on the mother of Christ, since Leonardo wanted to show the humility and the modesty appropriate to an image of the Virgin who is overflowing with joy at seeing the beauty of her Son. She is holding him tenderly on her lap, and she lets her pure gaze fall on St John, who is depicted as a little boy playing with a lamb; and this is not without a smile from St Anne, who is supremely joyful as she contemplates the divinity of her earthly progeny. These ideas were truly worthy of Leonardo's intellect and genius. As I shall describe, this cartoon was subsequently taken to France.

Leonardo also did a portrait of Ginevra, the wife of Amerigo Benci, a very beautiful painting. He abandoned the work he was doing for the friars and they went back to Filippino, who, however, died before he could finish it.

For Francesco del Giocondo Leonardo undertook to execute the portrait of his wife, Mona Lisa. He worked on this painting for four years, and then left it still unfinished; and today it is in the possession of King Francis of France, at Fontainebleau. If one wanted to see how faithfully art can imitate nature, one could readily perceive it from this head; for here Leonardo subtly reproduced every living detail. The eyes had their natural lustre and moistness, and around them were the lashes and all those rosy and pearly tints that demand the greatest delicacy of execution. The evebrows were completely natural, growing thickly in one place and lightly in another and following the pores of the skin. The nose was finely painted, with rosy and delicate nostrils as in life. The mouth, joined to the flesh-tints of the face by the red of the lips, appeared to be living flesh rather than paint. On looking closely at the pit of her throat one could swear that the pulses were beating. Altogether this picture was painted in a manner to make the most confident artist - no matter who - despair and lose heart. Leonardo also made use of this device: while he was painting Mona Lisa, who was a very beautiful woman, he employed singers and musicians or jesters to keep her full of merriment and so chase away the melancholy that painters usually give to portraits. As a result, in this painting of Leonardo's there was a smile so pleasing that it seemed divine rather than human; and those who saw it were amazed to find that it was as alive as the original.

The great achievements of this inspired artist so increased his prestige that everyone who loved art, or rather every single person in Florence, was anxious for him to leave the city some memorial; and it was being proposed everywhere that Leonardo should be commissioned to do some great and notable work which would enable the state to be honoured and adorned by his discerning talent, grace, and judgement. As it happened the great hall of the council was being constructed under the architectural direction of Giuliano Sangallo, Simone Pollajuolo (known as Cronaca), Michelangelo Buonarroti, and Baccio d'Agnolo, as I shall relate at greater length in the right place. It was finished in a hurry, and after the head of the government and the chief citizens had conferred together, it was publicly announced that a splendid painting would be commissioned from Leonardo. And then he was asked by Piero Soderini, the Gonfalonier of Justice, to do a decorative painting for the council hall. As a start, therefore, Leonardo began work in the Hall of the Pope, in Santa Maria Novella, on a cartoon illustrating an incident in the life of Niccolò Piccinino, a commander of Duke Filippo of Milan. He showed a group of horsemen fighting for a standard, in a drawing which was regarded as very fine and successful because of the wonderful ideas he expressed in his interpretation of the battle. In the drawing, rage, fury, and vindictiveness are displayed both by the men and by the horses, two of which with their forelegs interlocked are battling with their teeth no less fiercely than their riders are struggling for the standard.

It is impossible to convey the fine draughtsmanship with which Leonardo depicted the soldiers' costumes, with their distinctive variations, or the helmet-crests and the other ornaments, not to speak of the incredible mastery that he displayed in the forms and lineaments of the horses which, with their bold spirit and muscles and shapely beauty, Leonardo portrayed better than any other artist. It is said that to draw the cartoon Leonardo constructed an ingenious scaffolding that he could raise or lower by drawing it together or extending it. He also conceived the wish to paint the picture in oils, but to do this he mixed such a thick composition for laying on the wall that, as he continued his painting in the hall, it started to run and spoil what had been done. So shortly afterwards he abandoned the work.

Leonardo went to Rome with Duke Giuliano de' Medici on the election of Pope Leo who was a great student of natural philosophy, and especially of alchemy. And in Rome he experimented with a paste made out of a certain kind of wax and made some light and billowy figures in the form of animals which he inflated with his mouth as he walked along and which flew above the ground until all the air escaped.¹ To the back of a very odd-looking lizard that was found by the gardener of the Belvedere he attached with a mixture of quicksilver some wings, made from the scales stripped from other lizards, which quivered as it walked along. Then, after he had given it eyes, horns, and a beard he tamed the creature, and keeping it in a box he used to show it to his friends and frighten the life out of them. Again, Leonardo used to get the intestines of a bullock scraped completely free of their fat,

^{1.} Literally, 'which by blowing into, he made fly through the air, but then when the wind (vento) ceased, they fell to the ground'. There has been considerable speculation as to what these figures really were. More than likely, Leonardo simply flew some little kites.

cleaned and made so fine that they could be compressed into the palm of one hand; then he would fix one end of them to a pair of bellows lying in another room, and when they were inflated they filled the room in which they were and forced anyone standing there into a corner. Thus he could expand this translucent and airy stuff to fill a large space after occupying only a little, and he compared it to genius. He perpetrated hundreds of follies of this kind, and he also experimented with mirrors and made the most outlandish experiments to discover oils for painting and varnish for preserving the finished works.

Once, when he was commissioned a work by the Pope, Leonardo is said to have started at once to distil oils and various plants in order to prepare the varnish; and the Pope is supposed to have exclaimed: 'Oh dear, this man will never do anything. Here he is thinking about finishing the work before

he even starts it!'

Leonardo and Michelangelo strongly disliked each other, and so Michelangelo left Florence because of their rivalry (with permission from Duke Giuliano) after he had been summoned by the Pope to discuss the completion of the façade of San Lorenzo; and when he heard this Leonardo also left Florence and went to France. The king had obtained several of his works and was very devoted to him, and he asked Leonardo to paint the cartoon of St Anne. But, characteristically, Leonardo for a long time put him off with mere words.

Finally, in his old age Leonardo lay sick for several months,

^{1.} To virtù - possibly meaning 'virtue'.

and feeling that he was near to death he earnestly resolved to learn about the doctrines of the Catholic faith and of the good and holy Christian religion. Then, lamenting bitterly, he confessed and repented, and, although he could not stand up, supported by his friends and servants he received the Blessed Sacrament from his bed. He was joined by the king, who often used to pay him affectionate visits, and having respectfully raised himself in his bed he told the king about his illness and what had caused it, and he protested that he had offended God and mankind by not working at his art as he should have done. Then he was seized by a paroxysm, the forerunner of death, and, to show him favour and to soothe his pain, the king held his head. Conscious of the great honour being done to him, the inspired Leonardo breathed his last in the arms of the king; he was then seventy-five years old.¹

All who had known Leonardo were grieved beyond words by their loss, for no one had ever shed such lustre on the art of painting.

In appearance he was striking and handsome, and his magnificent presence brought comfort to the most troubled soul; he was so persuasive that he could bend other people to his own will. He was physically so strong that he could withstand any violence; with his right hand he would bend the iron ring of a doorbell or a horseshoe as if they were lead. He was so generous that he sheltered and fed all his friends, rich or poor, provided they were of some talent or worth. By his every action Leonardo adorned and honoured the meanest and humblest dwelling-place. Through his birth, therefore, Florence

^{1.} Leonardo died aged sixty-seven.

received a very great gift, and through his death it sustained an incalculable loss. In painting he brought to the technique of colouring in oils a way of darkening the shadows which has enabled modern painters to give great vigour and relief to their figures. He showed his powers as a sculptor in the three bronze figures over the north door of San Giovanni which were executed by Giovanfrancesco Rustici, under Leonardo's direction, and which as far as design and finish are concerned are the finest casts yet seen in modern times.

Because of Leonardo we have a deeper knowledge of human anatomy and the anatomy of the horse. And because of his many wonderful gifts (although he accomplished far more in words than in deeds) his name and fame will never be extinguished.

Life of Raphael of Urbino

PAINTER AND ARCHITECT, 1483-1520

With wonderful indulgence and generosity heaven sometimes showers upon a single person from its rich and inexhaustible treasures all the favours and precious gifts that are usually shared, over the years, among a great many people. This was clearly the case with Raphael Sanzio of Urbino, an artist as talented as he was gracious, who was endowed by nature with the goodness and modesty to be found in all those exceptional men whose gentle humanity is enhanced by an affable and pleasing manner, expressing itself in courteous behaviour at all times and towards all persons.

Nature sent Raphael into the world after it had been vanquished by the art of Michelangelo and was ready, through Raphael, to be vanquished by character as well. Indeed, until Raphael most artists had in their temperament a touch of uncouthness and even madness that made them outlandish and eccentric; the dark shadows of vice were often more evident in their lives than the shining light of the virtues that can make men immortal. So nature had every reason to display in Raphael, in contrast, the finest qualities of mind accompanied by such grace, industry, looks, modesty, and excellence of character as would offset every defect, no matter how serious, and any vice, no matter how ugly. One can claim without fear of contradiction that artists as outstandingly gifted as Raphael are not simply men but, if it be allowed to say so,

mortal gods, and that those who leave on earth an honoured name in the annals of fame may also hope to enjoy in heaven a just reward for their work and talent.

Raphael was born in Urbino, a notable Italian city, on Good Friday in the year 1483, at three o'clock in the night. His father was Giovanni Santi, a mediocre painter but an intelligent man who knew how to set his children on the right path which, through bad fortune, he himself had not been shown when young. Giovanni also understood how important it was that children should be reared on the milk of their own mothers rather than of wet-nurses; and so he insisted that Raphael (the name he chose, very felicitously, for the baptism) should, being his first child (and as it happened his last), be suckled by his own mother and should be trained in childhood in the family ways at home rather than in the houses of peasants or common people with their less gentle, indeed, their rough manners and behaviour. And as Raphael grew up Giovanni began to instruct him in painting, because he saw that the boy was attracted by the art and was very intelligent. So before many years passed Raphael came to be of great help to his father in the numerous works that Giovanni executed in the state of Urbino.

Eventually Raphael's kind and devoted father, knowing that his son could make little progress under him, resigned himself to placing him with Pietro Perugino who, as he had heard, was the most outstanding painter of the time.¹ He went, therefore, to Perugia, but he failed to find Perugino, and so to occupy his time usefully he started work on some paintings for San Francesco.

^{1.} Pietro Perugino (c. 1445/50-1523).

After Pietro had returned from Rome, Giovanni, who was a man of good breeding and manners, struck up a friendship with him, and when the time seemed ripe he told him what he wanted as tactfully as he could. Pietro, who was also very courteous and a great admirer of talent, agreed to take Raphael; and so Giovanni returned in high spirits to Urbino and then took the boy back with him to Perugia, not without many tears from his mother who loved him dearly. When Pietro saw how well Raphael could draw and what fine manners and character he had he formed a high opinion of him, which in time proved to be completely justified.

It is very remarkable that, in studying Pietro's style, Raphael imitated his work so exactly in every detail that it was impossible to tell the difference between the copies he made and his master's originals. And it was also impossible to distinguish clearly between Raphael's own original works and Pietro's, as is evident from some figures that he painted in oils on a panel in San Francesco in Perugia for Maddalena degli Oddi; these represent the Assumption of Our Lady into heaven and her Coronation by Jesus Christ, and among them are the twelve apostles standing about the tomb of Our Ladv and contemplating the celestial vision. At the foot of the panel, in a predella divided into three scenes, are some little figures enacting the Annunciation, with Our Lady and the angel, the Adoration of Christ by the Magi, and the Presentation in the Temple, where Simeon takes the Child in his arms. This work was executed with marvellous diligence, and anyone who is not an expert would swear that it was by Pietro and not, as it undoubtedly is, by Raphael.

After Pietro had gone to Florence on business, Raphael left Perugia in company with some friends for Città di Castello, where he painted a panel for Sant'Agostino in the same style as the picture he had just finished. For San Domenico he did a similar work, showing the crucifixion, and if his name were not written on it everyone would think it was by Pietro. For the church of San Francesco in the same city he painted a small panel picture of the Marriage of Our Lady which shows very forcefully the way his own style was improving as he surpassed the work of Pietro. This painting contains a temple in perspective drawn with great care and devotion and showing what amazingly difficult problems Raphael was ready to tackle.

The pictures he did in the style of Perugino brought Raphael considerable fame, and in the meanwhile it happened that Pope Pius II commissioned Pintoricchio to decorate the library of the cathedral at Siena; so being a friend of Raphael's and knowing his excellence as a draughtsman Pintoricchio took him to Siena, where he did some of the drawings and cartoons for the library. The reason he left what he was doing unfinished was that while in Siena he heard some painters enthusiastically praising the fine cartoon for the great hall that Leonardo had drawn in the Hall of the Pope at Florence and the nudes that Michelangelo Buonarroti had executed in rivalry with Leonardo, and with even better results. And so, because of his love of painting, Raphael became so anxious to see

r. Bernardino Pintoricchio (c. 1454–1513) left as his chief works fresco cycles in the Borgia Apartments at the Vatican and in the Piccolomini library at Siena.

these works that he put aside what he was doing and, ignoring his own immediate interest, went off to Florence.

On his arrival the city pleased him as much as did the works of Leonardo and Michelangelo (which indeed came as a revelation to him) and he made up his mind to stay in Florence for some time. He became friendly with a group of painters including Ridolfo Ghirlandaio, Aristotile Sangallo, and others, and he was held in great respect in Florence, especially by Taddeo Taddei, who liked to see him always in his house or at his table, being a great admirer of talented men. In order not to be outdone in kindness Raphael, who was courtesy itself, painted for Taddei two pictures executed in his original style derived from Pietro but also in the manner he was then starting to adopt and which, as I shall explain, was far superior. (These pictures are still in the house belonging to Taddeo Taddei's heirs.) Raphael also became a close friend of Lorenzo Nasi, and as Lorenzo had just got married he painted for him a picture which showed Our Lady and between her legs the Christ-Child to whom a laughing St John is offering a bird, to the great joy and delight of them both. The children are shown in an attitude of youthful simplicity, which is lovely to see, and, moreover, the figures are so well coloured and finished so meticulously that they seem to be made of living flesh rather than paint. Our Lady as well seems truly full of grace and divinity; and lastly, the foreground, the landscape, and all the rest of this painting are extremely beautiful. It was held in great veneration by Lorenzo Nasi as long as he lived, as much in memory of Raphael, whose dear friend he had been, as for its majesty and excellence. But subsequently, on 17 November 1548, it came to grief when a landslide on the hill of San Giorgio destroyed Lorenzo's house along with other nearby buildings, including the ornate and beautiful houses belonging to the heirs of Marco del Nero. However, the pieces were found among the debris of the ruined house and they were put together again as best he could by Lorenzo's son, Battista, who was very devoted to the art.

After he had done these works, Raphael had to leave Florence and go to Urbino as both his father Giovanni and his mother had died, and so all the family affairs were in a muddle. And while he was living in Urbino, for Guidobaldo da Montefeltro (then commander of the Florentine troops) he painted two small but very beautiful Madonnas (in his second style), which are today in the possession of Guidobaldo, the most illustrious duke of Urbino. For the same patron he also executed a picture of Christ praying in the Garden with the three apostles sleeping some distance away. This painting is so finely finished that it is like an exquisite miniature. For a long time it was owned by Francesco Maria, duke of Urbino, and then it was presented by the most illustrious Signora Leonora, his consort, to the Venetians Don Paolo Giustiniano and Don Pietro Quirini, hermits at the holy hermitage of Camaldoli. In her honour they afterwards placed it (as being a relic and a rare work of art, in a word as being by Raphael of Urbino) in the room of the father superior of the hermitage, where it is treated with the reverence it deserves.

After he had executed this work and put his affairs in order, Raphael went back to Perugia, where in the church of the Servites, for the chapel of the Ansidei, he painted a panel picture of Our Lady, St John the Baptist, and St Nicholas; and for the Lady Chapel in San Severo (a small monastery of the Order of Camaldoli) he did a fresco painting of Christ in Glory and a God-the-Father with angels around him and six seated figures of saints: St Benedict, St Romuald, St Lawrence, St Jerome, St Maurus, and St Placid, three on each side. On this work, which was at that time regarded as an extremely beautiful example of fresco, Raphael signed his name in big, very legible characters. In the same city he was also commissioned by the nuns of St Anthony of Padua to paint a panel picture of Our Lady with Jesus Christ sitting on her lap and (as pleased those simple, holy women) fully clothed, and with St Peter, St Paul, St Cecilia, and St Catherine on either side of the Madonna. Raphael depicted the two saintly virgins with the most beautiful and graceful expressions and the most wonderfully varied head-dresses anywhere to be seen; and this was an unusual thing in those days. In a lunette over the panel he painted a very fine God-the-Father and in the predella of the altar he did three scenes with little figures: Christ praying in the Garden, carrying the cross (and in this scene the gestures of the soldiers dragging him along are beautifully expressed) and lying dead in the lap of his mother. This is certainly a marvellous and devout work of art, held in great honour by those nuns and highly admired by all painters. I must record that it was recognized, after Raphael had been in Florence, that influenced by the many works he saw painted by the great masters he changed and improved his style of painting so much that it had nothing to do with his earlier manner; in fact, the two styles seemed to be the work of two different artists, one of whom was more proficient than the other.

Before Raphael left Perugia, Madonna Atalanta Baglioni begged him to consent to paint a panel picture for her chapel in the church of San Francesco; however, as he could not do it then he promised that after returning from Florence (where he had to go to see to his affairs) he would not disappoint her. And so after he had arrived in Florence, where he devoted himself to intense study of the art of painting, he prepared the cartoon, with the intention, which he fulfilled, of going back to execute the picture as soon as he had the chance.

While Raphael was living in Florence, Agnolo Doni (who was very cautious with his money in other things, but spent it readily, although still as economically as possible, on works of painting and sculpture, which gave him immense pleasure) commissioned Raphael to paint the portraits of himself and his wife; and these, in Raphael's new style, may be seen in the possession of his son Giovanbattista, in the beautiful and spacious house that Agnolo built on the Corso de' Tintori in Florence, near the Canto degli Alberti.

For Domenico Canigiano, Raphael painted a picture of Our Lady, with the Infant Jesus welcoming a little St John brought to him by St Elizabeth who, as she holds him forward, is gazing with a most animated expression at St Joseph, who stands there with both hands resting on a staff and inclines his head towards her, as if praising the greatness of God and marvelling that at her age she should have such a young child. All the figures are shown wondering at the feeling and reverence with which, despite their tender years, the two cousins are caressing each other; not to mention that every stroke of colour made by the brush in the heads, hands, and feet appears to be living flesh rather than mere paint applied by the hand of an artist. Today this magnificent

picture belongs to Domenico Canigiano's heirs, who treasure it with the respect due to a work by Raphael of Urbino.

This great painter studied the old paintings of Masaccio in the city of Florence; and what he saw in the works of Leonardo and Michelangelo inspired him to study even more intensely, so that there followed a striking improvement in his style and skill. Raphael was especially fond of Fra Bartolommeo of San Marco, who was among his circle of friends in Florence and whose use of colours he greatly admired and tried hard to imitate. In return, Raphael taught this good priest the principles of perspective, of which the friar had formerly been ignorant.

However, when their friendship was at its height Raphael was recalled to Perugia, where he first of all finished the painting for Madonna Atalanta Baglioni, the cartoon for which, as I said earlier, he had drawn while in Florence. In this inspired painting there is a dead Christ being carried to the sepulchre, executed with such loving care and so fresh that it appears to have been only just finished. In composing this work Raphael imagined to himself the grief as they lay him to rest felt by the nearest and dearest relations of some much loved person, who had sustained the happiness, dignity and well-being of a whole family. One sees the swooning figure of Our Lady and the graceful heads of other weeping figures, notably St John who, with his hands clasped, drops his head in a way that would move the hardest heart to pity. The diligence, the skill, the devotion, and the grace expressed in this work are really marvellous, and everyone who sees it is amazed at the attitudes of its figures, the beauty of the draperies and, in brief, the perfection of its every detail.

After he had finished this work, Raphael went back to Florence where the Dei, a Florentine family, commissioned him to paint an altarpiece for their chapel in Santo Spirito. He almost completed the sketch for this work, but in the meantime he did a painting which was subsequently sent to Siena. (This picture remained with Domenico Ghirlandaio, so that he could finish a piece of blue drapery, when Raphael left Florence.) At that time Bramante of Urbino, who was working for Julius II, because he was distantly related to Raphael and came from the same part of the world wrote to him saying that he had persuaded the Pope to build some new apartments where Raphael would have the chance to show what he could do.

Raphael found the proposal agreeable and so he left for Rome, abandoning his work in Florence and leaving the panel for the Dei family in the unfinished condition in which Baldassare later, after Raphael's death, had it placed in the parish church of his native town. When he arrived in Rome Raphael found several artists at work decorating the rooms in the Vatican, some of which were already finished. Piero della Francesca had completed a scene in one room, Luca da Cortona had nearly finished a wall in another, and Don Pietro della Gatta, abbot of San Clemente, had started several paintings. Moreover, Bramantino of Milan had executed a number of figures, mostly portraits from life, which were regarded as being extremely beautiful. However, after he had been welcomed very affectionately by Pope Julius, Raphael started to paint in the Stanza della Segnatura a fresco showing the theologians reconciling Philosophy and Astrology with Theology, in which there are portraits of all the sages of the world

shown disputing among themselves in various ways.1 Standing apart are some astrologers who have drawn various kinds of figures and characters relating to geomancy and astrology on some little tablets which, by the hands of some very beautiful angels, they are sending to the evangelists to expound. Among them is Diogenes with his cup, lying deep in thought on the steps: this is a finely conceived figure which deserves high praise for its beauty and the appropriate negligence of its clothing. There, also, are Aristotle and Plato, one holding the Timaeus, the other with the Ethics; and round them in a circle is a great school of philosophers. The astrologers and geometers are using compasses to draw innumerable figures and characters on their tablets; and it is hardly possible to describe how splendid they look. Among them is a handsomely built young man who is inclining his head and throwing out his arms in admiration: this is a portrait of Duke Federigo II of Mantua, who was in Rome at that time. Similarly, there is a figure stooping down and holding in its hand a pair of compasses with which it is making a circle on one of the tablets; and this, they say, is the architect Bramante, portrayed so realistically that he seems to be alive. Beside a figure with its back turned,

I. Vasari's account of Raphael's work is very muddled. Very briefly: Raphael was working in the Stanza della Segnatura (part of the series of rooms that Julius was having decorated) by 1509. Here, the two chief frescoes are known as the School of Athens and the Disputation concerning the Blessed Sacrament. In the Stanza d'Elidoro the chief subjects are the Expulsion of Heliodorus from the Temple, the Liberation of St Peter, and the Miracle of the Mass at Bolsena. The scenes in the Stanza dell'Incendio (containing the Fire in the Borgo) and the Sala di Constantino were mostly executed by Raphael's assistants.

holding a globe of the heavens, is a portrait of Zoroaster, and next to him is Raphael, the artist himself, in a self-portrait drawn with the help of a mirror. He is shown with a youthful head, an air of great modesty, and a gracious and attractive manner, and he is wearing a black cap. Also defying description are the beauty and goodness shown in the heads and figures of the evangelists, in whose faces Raphael depicted a very lifelike air of intentness and concentration, notably in those who are writing. Thus behind St Matthew, who is copying into a book the characters from the inscribed tablets held out to him by an angel, is an old man who had put a sheaf of papers on his knee and is now copying everything that St Matthew is writing; as he concentrates in this awkward position he seems to be twisting his jaws and his head up and down with the strokes of his pen. As well as the many fine details with which Raphael expressed his ideas, one must remark the composition of the entire scene; for it is convincingly arranged with such order and proportion that by the genius shown in this work Raphael clearly demonstrated his determination to be the undisputed master among all those using the brush. He also embellished the picture with a view in perspective and with a number of figures, executed in such a soft and delicate style that Pope Julius was persuaded to demolish all the scenes painted by the other artists, both the new and the old, so that Raphael alone might be honoured before all those who had laboured there previously.

By now Raphael had made a great name for himself in Rome. He had developed a smooth and graceful style that everyone admired, he had seen any number of antiquities in that city, and he studied continuously; none the less, his figures still lacked the indefinable grandeur and majesty that he now started to give them.

What happened was that Michelangelo at that time made his terrifying outburst against the Pope in the Sistine Chapel and was forced to run away to Florence. So then Bramante, who had the keys of the chapel, being a friend of Raphael brought him to see Michelangelo's work and study his technique. And this was the reason why, though it was already finished, Raphael immediately repainted the prophet Isaiah which is to be seen in Sant'Agostino in Rome, above the St Anne by Andrea Sansovino; and what he had seen of Michelangelo's paintings enabled him to give his own style more majesty and grandeur, so that he improved the picture out of all recognition. When Michelangelo saw Raphael's work later on he was convinced, and rightly, that Bramante had deliberately done him that wrong for the sake of Raphael's reputation and benefit.

While this favoured artist was producing such marvellous work, through the envy of fortune Julius II, a patron of genius and a lover of all good art, was overtaken by death. He was succeeded by Leo X who showed himself anxious for the work that had been done to be continued and thus enabled the genius of Raphael to soar even higher.

In fact, whereas pictures by others may be called simply pictures, those painted by Raphael are truth itself: for in his figures the flesh seems to be moving, they breathe, their pulses beat, and they are utterly true to life. Thus, having already won great praise Raphael became even more renowned, and many Latin verses were composed in his honour.

A fine painting, of the Madonna, was sent by Raphael to

Florence. Today it is in Duke Cosimo's palace, in the chapel of the new apartments which were built and decorated by me, where it serves as an altarpiece. This picture contains a very old St Anne, seated and holding out to Our Lady her naked son whose body is so beautiful and whose face is so lovely that his smile lightens the heart of anyone who looks at him. And in the figure of Our Lady herself Raphael showed all the beauty that belongs to an image of the Virgin Mary: modesty in her eyes, honour in the brow, grace in the nose, and virtue in the mouth; not to mention that Our Lady's garment reflects her infinite simplicity and purity. I do not believe any other painting of this kind could possibly be better. Moreover, the picture contains a nude St John, seated, and a female saint who is also beautifully depicted. For background there is a building in which Raphael painted a linen-covered window to give light to the room where he placed the figures.

While in Rome, Raphael painted a large picture in which he portrayed Pope Leo, Cardinal Giulio de' Medici, and Cardinal de' Rossi. In this work the figures appear to be truly in the round rather than painted. One can see the pile of the velvet, with the Pope's damask robes rustling and shining, the soft and natural fur of the linings, and the gold and silk imitated so skilfully that they seem to be real gold and silk rather than paint. Then there is an illuminated book of parchment which is utterly realistic and an inexpressibly beautiful little bell of wrought silver. Among the other details there is also, on the Pope's throne, a ball of burnished gold which is so bright that like a mirror it reflects the light from the windows, the Pope's shoulders, and the walls around the room. Indeed, everything

in this picture is executed so diligently that no other painter could ever possibly surpass it. The Pope was moved to reward him very generously; and today, it may be seen in Florence, in the duke's wardrobe.

Raphael also executed portraits of Duke Lorenzo and Duke Giuliano, which are coloured with incomparable grace; and these perfect works now belong to the heirs of Ottaviano de' Medici and are also in Florence.

In time the style Raphael had adopted so effortlessly from Pietro when he was a young man started to impede and restrict his development, since it was pedantic, harsh, and feeble in draughtsmanship. Taking immense pains, he forced himself as a grown man to learn within the space of a few months something which demanded the easy aptitude of youth and years of study. To be sure, the artist who does not learn early on the principles and the style that he intends to adopt and who does not gradually solve the problems of his art by practice, striving to learn and master every aspect of it, will rarely become perfect. If he does, it will take far longer and considerably more effort.

At the time when Raphael determined to change and improve his style he had never studied the nude as intensely as it requires, for he had only copied it from life, employing the methods he had seen used by Perugino, although he gave his figures a grace that he understood instinctively. So he began to study the nude form and to compare the muscles as revealed in anatomical drawings or dissected corpses with them as they are seen, less starkly defined, in the living body. He saw how the soft and fleshy parts are formed and how from different viewpoints various graceful convolutions appear, and also the

visual effects of inflating, raising, and lowering the whole body or one of its members. He also studied the articulation of the bones, nerves, and veins, and he mastered all the points that a great painter needs to know.

None the less, Raphael realized that in this matter he could never rival the accomplishments of Michelangelo, and therefore, like the judicious man he was, he reflected that painters are not confined to making numerous studies of naked men

but can range over a very wide field.

Having considered all this, therefore, Raphael, being unable to compete with Michelangelo in the branch of painting to which he had set his hand, resolved to emulate and perhaps surpass him in other respects. So he decided not to waste his time by imitating Michelangelo's style but to attain a catholic excellence in the other fields of painting that have been described. His example might well have been followed by many contemporary artists who, because they have confined themselves to studying the works of Michelangelo, have failed to imitate him or reach his standard of perfection; if they had followed Raphael, instead of wasting their time and creating a style that is very harsh and laboured, that lacks charm and is defective in colouring and invention, they would, by aiming at a catholic excellence and trying to become proficient in the other fields of painting, have benefited themselves and everyone else.

But now that I have discussed these questions I must return to the life and death of Raphael. It happened that he was very friendly with Cardinal Bernardo Dovizi of Bibbiena, who for many years kept pestering him to get married. Without giving the cardinal a direct yes or no, Raphael had delayed the issue for a good while by saying that he wanted to wait for three or four years. So the years passed, and then when he was not expecting it the cardinal reminded him of his promise. Thinking himself under an obligation, like the courteous man he was, Raphael refused to go back on his word and he agreed to marry a niece of the cardinal's. But he resented this entanglement and kept putting things off; and after several months still the wedding had not taken place. All the same, his motives were not dishonourable; for the truth of the matter was that as he had served the court for many years and Pope Leo owed him a great deal of money he had been dropped the hint that, when the hall he was painting was finished, to reward him for his labour and talent the Pope would give him a red hat. (For the Pope had already decided to create a number of new cardinals, among whom there were several less deserving than Raphael.)

Meanwhile, Raphael kept up his secret love affairs and pursued his pleasures with no sense of moderation. And then on one occasion he went to excess, and he returned home afterwards with a violent fever which the doctors diagnosed as having been caused by heat-stroke. Raphael kept quiet about his incontinence and, very imprudently, instead of giving him the restoratives he needed they bled him until he grew faint and felt himself sinking. So he made his will: and first, as a good Christian, he sent his mistress away, leaving her the means to live a decent life. Then he divided his belongings among his disciples, Giulio Romano, whom he had always loved dearly, the Florentine Giovanni Francesco, called Il Fattore, and a priest I know nothing about who was a relation of his and came from Urbino. Next he stipulated that some of his wealth should be used for restoring with new masonry one of the ancient tabernacles in Santa Maria Rotonda and for making an altar with a marble statue of Our Lady; and he chose this church, the Pantheon, as his place of rest and burial after death. He left all the rest of his possessions to Giulio and Giovanni Francesco, and he appointed as his executor Baldassare da Pescia, then the Pope's datary. Having made his confession and repented, Raphael ended his life on Good Friday, the same day he was born. He was thirty-seven when he died; and we can be sure that just as he embellished the world with his talent so his soul now adorns heaven itself.

As he lay dead in the hall where he had been working they placed at his head the picture of the Transfiguration which he had done for Cardinal de' Medici; and the sight of this living work of art along with his dead body made the hearts of everyone who saw it burst with sorrow. In memory of Raphael, the cardinal later placed this picture on the high altar of San Pietro in Montorio, where because of the nobility of everything that Raphael ever did it was afterwards held in great reverence. Raphael was given the honourable burial that his noble spirit deserved, and there was no artist who did not weep with sorrow as he followed him to the grave.

When this noble craftsman died, the art of painting might well have died with him; for when Raphael closed his eyes,

painting was left as if blind.

For those of us who survive him, it remains to imitate the good, or rather the supremely excellent method that he left for our example and, as is our duty and as his merits demand, always to remember what he did with gratitude and to pay him the highest honour in what we say. For to be sure, because of Raphael, art, colouring, and invention have all three been brought to a pitch of perfection that could scarcely have been

hoped for; nor need anyone ever hope to surpass him. Apart from the benefits that he conferred on painting, as a true friend of the art, while he was alive he never ceased to show us how to conduct ourselves when dealing with great men, with those of middle rank or station, and with the lowest. And among his exceptional gifts I must acknowledge one of great value that fills me with amazement; namely, that heaven gave him the power to bring about in our profession a phenomenon completely alien to our character as painters. What happened was that craftsmen who worked with Raphael began to live in a state of natural harmony and agreement. (This was true not only of artists of ordinary talent but also of those who made some pretence to be great men, and painting produces any number of those.) At the sight of Raphael, all their bad humour died away, and every base and unworthy thought left their minds. This harmony was never greater than while Raphael was alive; and this state of affairs came about because the artists were won over by his accomplishments and his courteous behaviour, and above all by the loving-kindness of his nature. Raphael was so gentle and so charitable that even animals loved him, not to speak of men.

It is said that if any painter who knew Raphael (and even any who did not) asked him for a drawing, he would leave what he was doing himself in order to help. And he always kept employed a vast number of artists whom he helped and instructed with a love that belonged rather to children of his own than to his fellow craftsmen. He was never seen leaving his house to go to court but that he was accompanied by fifty painters, all able and excellent artists, going with him to do him honour.

In short, Raphael lived more like a prince than a painter. The art of painting was supremely fortunate in securing the allegiance of a craftsman who, through his virtues and his genius, exalted it to the very skies. It is fortunate also in having disciples today who follow in the footsteps of Raphael. For he showed them how to live and how to combine virtue and art; and in him these qualities prevailed on the magnificent Julius II and the munificent Leo X, despite their exalted dignity and rank, to make him their intimate friend and show him every mark of favour. Because of their favours and rewards Raphael was able to win great honour both for himself and his art. Happy, too, may be called all those who were employed in Raphael's service and worked under him; for whoever followed him discovered that he had arrived at a safe haven. Just so, those who follow Raphael in the future will win fame on earth, and if they follow also the example of his life they will be rewarded in heaven.

Life of Michelangelo Buonarroti

FLORENTINE PAINTER, SCULPTOR, AND ARCHITECT, 1475–1564

Birth

In the year 1475 in the Casenino, under a fateful and lucky star, the virtuous and noble wife of Lodovico di Leonardo Buonarroti gave birth to a baby son. That year Lodovico (who was said to be related to the most noble and ancient family of the counts of Canossa) was visiting magistrate at the township of Chiusi and Caprese near the Sasso della Vernia (where St Francis received the stigmata) in the diocese of Arezzo. The boy was born on Sunday, 6 March, about the eighth hour of the night; and without further thought his father decided to call him Michelangelo, being inspired by heaven and convinced that he saw in him something supernatural and beyond human experience. This was evident in the child's horoscope which showed Mercury and Venus in the house of Jupiter, peaceably disposed; in other words, his mind and hands were destined to fashion sublime and magnificent works of art. Now when he had served his term of office Lodovico returned to Florence and settled in the village of Settignano, three miles from the city, where he had a family farm. That part of the country is very rich in stone, especially in quarries of greystone which are continuously worked by stone-cutters and sculptors, mostly local people; and

Michelangelo was put out to nurse with the wife of one of the stone-cutters. That is why once, when he was talking to Vasari, he said jokingly:

'Giorgio, if my brains are any good at all it's because I was born in the pure air of your Arezzo countryside, just as with my mother's milk I sucked in the hammer and chisels I use for

my statues.'

As time passed and Lodovico's family grew bigger he found himself, as he enjoyed only a modest income, in very difficult circumstances and he had to place his sons in turn with the Wool and Silk Guilds. When Michelangelo was old enough he was sent to the grammar school to be taught by Francesco of Urbino; but he was so obsessed by drawing that he used to spend on it all the time he possibly could. As a result he used to be scolded and sometimes beaten by his father and the older members of the family, who most likely considered it unworthy of their ancient house for Michelangelo to give his time to an art that meant nothing to them.

The Pietà and the David

The French cardinal of Saint-Denis, called Cardinal Rouen became anxious to employ Michelangelo's rare talents to leave some suitable memorial of himself in the great city of Rome; and so he commissioned Michelangelo to make a Pietà of marble in the round, and this was placed, after it was finished, in the chapel of the Madonna della Febbre in St Peter's, where the temple of Mars once stood. It would be impossible for any craftsman or sculptor no matter how brilliant ever to surpass the grace or design of this work or try to cut and polish the

marble with the skill that Michelangelo displayed. For the Pietà was a revelation of all the potentialities and force of the art of sculpture. Among the many beautiful features (including the inspired draperies) this is notably demonstrated by the body of Christ itself. It would be impossible to find a body showing greater mastery of art and possessing more beautiful members, or a nude with more detail in the muscles, veins and nerves stretched over their framework of bones, or a more deathly corpse. The lovely expression of the head, the harmony in the joints and attachments of the arms, legs, and trunk, and the fine tracery of pulses and veins are all so wonderful that it staggers belief that the hand of an artist could have executed this inspired and admirable work so perfectly and in so short a time. It is certainly a miracle that a formless block of stone could ever have been reduced to a perfection that nature is scarcely able to create in the flesh. Michelangelo put into this work so much love and effort that (something he never did again) he left his name written across the sash over Our Lady's breast. The reason for this was that one day he went along to where the statue was and found a crowd of strangers from Lombardy singing its praises; then one of them asked another who had made it, only to be told: 'Our Gobbo from Milan.'

Michelangelo stood there not saying a word, but thinking it very odd to have all his efforts attributed to someone else. Then one night, taking his chisels, he shut himself in with a light and carved his name on the statue.

This work did wonders for Michelangelo's reputation. To be sure, there are some critics, more or less fools, who say that he made Our Lady look too young. They fail to see that those who keep their virginity unspotted stay for a long time fresh and youthful, just as those afflicted as Christ was do the opposite. Anyhow, this work added more glory and lustre to Michelangelo's genius than anything he had done before.

Then some of his friends wrote to him from Florence urging him to return there as it seemed very probable that he would be able to obtain the block of marble that was standing in the Office of Works. Piero Soderini, who about that time was elected Gonfalonier for life,1 had often talked of handing it over to Leonardo da Vinci, but he was then arranging to give it to Andrea Contucci of Monte Sansovino, an accomplished sculptor who was very keen to have it. Now, although it seemed impossible to carve from the block a complete figure (and only Michelangelo was bold enough to try this without adding fresh pieces) Buonarroti had felt the desire to work on it many years before; and he tried to obtain it when he came back to Florence. The marble was eighteen feet high, but unfortunately an artist called Simone da Fiesole had started to carve a giant figure, and had bungled the work so badly that he had hacked a hole between the legs and left the block completely botched and misshapen. So the wardens of Santa Maria del Fiore (who were in charge of the undertaking) threw the block aside and it stayed abandoned for many years and seemed likely to remain so indefinitely. However, Michelangelo measured it again and calculated whether he could carve a satisfactory figure from the block by accommodating its attitude to the shape of the stone. Then he made up

^{1.} Soderini was elected *Gonfaloniere di Justizia* for life (in effect, head of the Florentine Republic) in 1502.

his mind to ask for it. Soderini and the wardens decided that they would let him have it, as being something of little value, and telling themselves that since the stone was of no use to their building, either botched as it was or broken up, whatever Michelangelo made would be worthwhile. So Michelangelo made a wax model of the young David with a sling in his hand; this was intended as a symbol of liberty for the Palace, signifying that just as David had protected his people and governed them justly, so whoever ruled Florence should vigorously defend the city and govern it with justice. He began work on the statue in the Office of Works of Santa Maria del Fiore, erecting a partition of planks and trestles around the marble; and working on it continuously he brought it to perfect completion, without letting anyone see it.

As I said, the marble had been flawed and distorted by Simone, and in some places Michelangelo could not work it as he wanted; so he allowed some of the original chisel marks made by Simone to remain on the edges of the marble, and these can still be seen today. And all things considered, Michelangelo worked a miracle in restoring life to something that had been left for dead.

After the statue had been finished, its great size provoked endless disputes over the best way to transport it to the Piazza della Signoria. However, Giuliano da Sangallo, with his brother Antonio, constructed a very strong wooden framework and suspended the statue from it with ropes so that when moved it would sway gently without being broken; then they drew it along by means of winches over planks laid on the ground, and put it in place. In the rope which held the figure

suspended he tied a slip-knot which tightened as the weight increased: a beautiful and ingenious arrangement. (I have a drawing by his own hand in my book showing this admirable, strong, and secure device for suspending weights.)

When he saw the David in place Piero Soderini was delighted; but while Michelangelo was retouching it he remarked that he thought the nose was too thick. Michelangelo, noticing that the Gonfalonier was standing beneath the Giant and that from where he was he could not see the figure properly, to satisfy him climbed on the scaffolding by the shoulders, seized hold of a chisel in his left hand, together with some of the marble dust lying on the planks, and as he tapped lightly with the chisel let the dust fall little by little, without altering anything. Then he looked down at the Gonfalonier, who had stopped to watch, and said:

'Now look at it.'

'Ah, that's much better,' replied Soderino. 'Now you've really brought it to life.'

And then Michelangelo climbed down, feeling sorry for those critics who talk nonsense in the hope of appearing well informed. When the work was finally finished he uncovered it for everyone to see. And without any doubt this figure has put in the shade every other statue, ancient or modern, Greek or Roman. Neither the Marforio in Rome, nor the Tiber and the Nile of the Belvedere, nor the colossal statues of Monte Cavello can be compared with Michelangelo's David, such were the satisfying proportions and beauty of the finished work. The legs are skilfully outlined, the slender flanks are beautifully shaped and the limbs are joined faultlessly to the trunk. The grace of this figure and the serenity of its pose

have never been surpassed, nor have the feet, the hands, and the head, whose harmonious proportions and loveliness are in keeping with the rest. To be sure, anyone who has seen Michelangelo's David has no need to see anything else by any other sculptor, living or dead.

The Sistine Chapel

Michelangelo had become so famous because of his Pietà and the colossal statue of David at Florence that when in 1503 Alexander VI died and Julius II was elected Pope (at which time Buonarroti was about twenty-nine years old) Julius very graciously summoned him to Rome to build his tomb.

Bramante, however, was constantly plotting with Raphael of Urbino to remove from the Pope's mind the idea of having Michelangelo finish the tomb. Bramante did this (being a friend and relation of Raphael and therefore no friend of Michelangelo's) when he saw the way his holiness kept praising and glorifying Michelangelo's work as a sculptor. He and Raphael suggested to Pope Julius that if the tomb were finished it would bring nearer the day of his death, and they said that it was bad luck to have one's tomb built while one was still alive. Eventually they persuaded his holiness to get Michelangelo to paint, as a memorial for his uncle Sixtus, the ceiling of the chapel that he had built in the Vatican. In this way Bramante and Michelangelo's other rivals thought they would divert his energies from sculpture, in which they realized he was supreme. This, they argued, would make things hopeless for him, since as he had no experience of colouring in fresco he would certainly, they believed, do less creditable work as a

painter. Without doubt, they thought, he would be compared unfavourably with Raphael, and even if the work were a success being forced to do it would make him angry with the Pope; and thus one way or another they would succeed in their purpose of getting rid of him. So when Michelangelo returned to Rome he found the Pope resolved to leave the tomb as it was for the time being, and he was told to paint the ceiling of the chapel. Michelangelo, being anxious to finish the tomb, and considering the magnitude and difficulty of the task of painting the chapel, and his lack of experience, tried in every possible way to shake the burden off his shoulders. But the more he refused, the more determined he made the Pope, who was a wilful man by nature and who in any case was again being prompted by Michelangelo's rivals, and especially Bramante. And finally, being the hot-tempered man he was, his holiness was all ready to fly into a rage.

However, seeing that his holiness was persevering, Michelangelo resigned himself to doing what he was asked. Then the Pope ordered Bramante to make the ceiling ready for painting, and he did so by piercing the surface and supporting the scaffolding by ropes. When Michelangelo saw this he asked Bramante what he should do, when the painting was finished, to fill up the holes. Bramante said: 'We'll think of it when it's time.' And he added that there was no other way. Michelangelo realized that Bramante either knew nothing about the matter or else was no friend of his, and he went to the Pope and told him that the scaffolding was unsatisfactory and that Bramante had not known how to make it; and the Pope replied, in the presence of Bramante, that Michelangelo should do it himself in his own way. So he arranged to have the scaffolding

erected on props which kept clear of the wall, a method for use with vaults (by which many fine works have been executed) which he subsequently taught to various people, including Bramante. In this instance he enabled a poor carpenter, who rebuilt the scaffolding, to dispense with so many of the ropes that when Michelangelo gave him what was over he sold them and made enough for a dowry for his daughter.

Michelangelo then started making the cartoons for the vaulting; and the Pope also decided that the walls that had been painted by previous artists in the time of Sixtus should be scraped clean and that Michelangelo should have fifteen thousand ducats for the cost of the work, the price being decided through Giuliano da Sangallo. Then being forced reluctantly, by the magnitude of the task, to take on some assistants, Michelangelo sent for help to Florence. He was anxious to show that his paintings would surpass the work done there earlier, and he was determined to show modern artists how to draw and paint. Indeed, the circumstances of this undertaking encouraged Michelangelo to aim very high, for the sake both of his own reputation and the art of painting; and in this mood he started and finished the cartoons. He was then ready to begin the frescoes, but he lacked the necessary experience. Meanwhile, some of his friends, who were painters, came to Rome from Florence in order to assist him and let him see their technique. Several of them were skilled painters in fresco, and they included Granaccio, Giuliano Bugiardini, Jacopo di Sandro, the elder Indaco, Angelo di Donnino, and Aristotile. Having started the work, Michelangelo asked them to produce some examples of what they could do. But when he saw that these were nothing like what he wanted he grew dissatisfied, and then one morning he made up his mind to scrap everything they had done. He shut himself up in the chapel, refused to let them in again, and would never let them see him even when he was at home. So, when they thought the joke was wearing thin, they accepted their dismissal and went back ashamed to Florence.

Thereupon, having arranged to do all the work by himself, Michelangelo carried it well on the way to completion; working with the utmost solicitude, labour, and study he refused to let anyone see him in case he would have to show what he was painting. As a result every day the people became more impatient.

Pope Julius himself was always keen to see whatever Michelangelo was doing, and so naturally he was more anxious than ever to see what was being hidden from him. So one day he resolved to go and see the work, but he was not allowed in, as Michelangelo would never have consented. Now when a third of the work was completed (as I found out from Michelangelo himself, to clear up any uncertainty) during the winter when the north wind was blowing several spots of mould started to appear on the surface. The reason for this was that the Roman lime, which is white in colour and made of travertine, does not dry very quickly, and when mixed with pozzolana,1 which is a brownish colour, forms a dark mixture which is very watery before it sets; then after the wall has been thoroughly soaked, it often effloresces when it is drying. Thus this salt efflorescence appeared in many places, although in time the air dried it up. When Michelangelo saw what was happening he despaired of the whole undertaking and was

^{1.} A volcanic dust found near Pozzuoli.

reluctant to go on. However, his holiness sent Giuliana da Sangallo to see him and explain the reason for the blemishes. Sangallo explained how to remove the moulds and encouraged him to continue. Then, when the work was half finished, the Pope who had subsequently gone to inspect it several times (being helped up the ladders by Michelangelo) wanted it to be thrown open to the public. Being hasty and impatient by nature, he simply could not bear to wait until it was perfect and had, so to say, received the final touch.

As soon as it was thrown open, the whole of Rome flocked to see it; and the Pope was the first, not having the patience to wait till the dust had settled after the dismantling of the scaffolds. Raphael da Urbino (who had great powers of imitation) changed his style as soon as he had seen Michelangelo's work and straight away, to show his skill, painted the prophets and sibyls of Santa Maria della Pace; and Bramante subsequently tried to persuade the Pope to let Raphael paint the other half of the chapel. When Michelangelo heard about this he complained of Bramante and revealed to the Pope, without reserve, many faults in his life and in his architectural works. (He himself, as it happened, was later to correct the mistakes made by Bramante in the fabric of St Peter's.) However, the Pope recognized Michelangelo's genius more clearly every day and wanted him to carry on the work himself; and after he had seen it displayed he was of the opinion that Michelangelo would do the other half even better. And so in twenty months Michelangelo brought the project to perfect completion without the assistance even of someone to grind his colours. Michelangelo at times complained that because of the haste the Pope imposed on him he was unable to finish it in the way

he would have liked; for his holiness was always asking him importunately when it would be ready. On one of these occasions Michelangelo retorted that the ceiling would be finished 'when it satisfies me as an artist'.

And to this the Pope replied: 'And we want you to satisfy us and finish it soon.'

Finally, the Pope threatened that if Michelangelo did not finish the ceiling quickly he would have him thrown down from the scaffolding. Then Michelangelo, who had good reason to fear the Pope's anger, lost no time in doing all that was wanted; and after taking down the rest of the scaffolding he threw the ceiling open to the public on the morning of All Saints' Day, when the Pope went into the chapel to sing Mass, to the satisfaction of the entire city.

Michelangelo wanted to retouch some parts of the painting a secco, as the old masters had done on the scenes below, painting backgrounds, draperies, and skies in ultramarine, and in certain places adding ornamentation in gold, in order to enrich and heighten the visual impact.¹ The Pope, learning that this ornamentation was lacking, and hearing the work praised so enthusiastically by all who saw it, wanted him to go ahead. However, he lacked the patience to rebuild the scaffolding, and so the ceiling stayed as it was. His holiness used to see Michelangelo often and he would ask him to have the chapel enriched with colours and gold, since it looked impoverished. And Michelangelo would answer familiarly:

'Holy Father, in those days men did not bedeck themselves

r. Fresco secco – as opposed to buon fresco – is painted on dry plaster and was rarely used, even for retouching, by Michelangelo's time.

in gold and those you see painted there were never very rich. They were holy men who despised riches.'

For this work Michelangelo was paid by the Pope three thousand crowns in several instalments, of which he had to spend twenty-five on colours. He executed the frescoes in great discomfort, having to work with his face looking upwards, which impaired his sight so badly that he could not read or look at the drawings save with his head turned backwards; and this lasted for several months afterwards. I can talk from personal experience about this, since when I painted five rooms in the great apartments of Duke Cosimo's palace if I had not made a chair where I could rest my head and relax from time to time I would never have finished; even so this work so ruined my sight and injured my head that I still feel the effects, and I am astonished that Michelangelo bore all that discomfort so well. In fact, every day the work moved him to greater enthusiasm, and he was so spurred on by his own progress and improvements that he felt no fatigue and ignored all the discomfort.

What a happy age we live in! And how fortunate are our craftsmen, who have been given light and vision by Michelangelo and whose difficulties have been smoothed away by this marvellous and incomparable artist! The glory of his achievements has won them honour and renown; he has stripped away the bandage that kept their minds in darkness and shown them how to distinguish the truth from the falsehoods that clouded their understanding. You artists should thank heaven for what has happened and strive to imitate Michelangelo in everything you do.

When the work was thrown open, the whole world came

running to see what Michelangelo had done; and certainly it was such as to make everyone speechless with astonishment. Then the Pope, exalted by the results and encouraged to undertake even more grandiose enterprises, generously rewarded Michelangelo with rich gifts and money. Michelangelo used to say of the extraordinary favours he was shown that they proved that his holiness fully recognized his abilities; and if sometimes, arising out of their intimacy, the Pope did him some hurt, he would heal it with extraordinary gifts and favours. There was an instance of this when Michelangelo once asked the Pope's permission to go to Florence for the feast day of St John and wanted some money from him for the purpose, and the Pope said:

'Well, what about this chapel? When will it be finished?'

'When I can, Holy Father,' said Michelangelo.

Then the Pope struck Michelangelo with a staff he was holding and repeated:

'When I can! When I can! What do you mean? I will soon make you finish it.'

However, after Michelangelo had gone back to his house to prepare for the journey to Florence, the Pope immediately sent his chamberlain, Cursio, with five hundred crowns to calm him down, as he was afraid that he would react in his usual unpredictable way; and the chamberlain made excuses for his holiness, explaining that such treatment was meant as a favour and a mark of affection. Then Michelangelo, because he understood the Pope's nature and, after all, loved him dearly, laughed it off, seeing that everything redounded to his profit and advantage and that the Pope would do anything to keep his friendship.

Death

Now, to be brief, I must record that Michelangelo's constitution was very sound, for he was lean and sinewy and although as a child he had been delicate and as a man he had suffered two serious illnesses he could always endure any fatigue and had no infirmity, save that in his old age he suffered from dysuria and gravel which eventually developed into the stone. For many years he was syringed by the hand of his dear friend, the physician Realdo Colombo, who treated him very devotedly. Michelangelo was of medium height, broad in the shoulders but well proportioned in all the rest of his body. As he grew old he took to wearing buskins of dogskin on his legs, next to the skin; he went for months at a time without taking them off, then when he removed the buskins often his skin came off as well. Over his stockings he wore boots of cordswain, fastened on the inside, as a protection against damp. His face was round, the brow square and lofty, furrowed by seven straight lines, and the temples projected considerably beyond the ears, which were rather large and prominent. His body was in proportion to the face, or perhaps on the large size; his nose was somewhat squashed, having been broken, as I told, by a blow from Torrigiano; his eyes can best be described as being small, the colour of horn, flecked with bluish and yellowish sparks. His eyebrows were sparse, his lips thin (the lower lip being thicker and projecting a little), the chin well formed and well proportioned with the rest, his hair black, but streaked with many white hairs and worn fairly short, as was his beard which was forked and not very thick.

About a year before Michelangelo's death Vasari secretly prevailed on Duke Cosimo de' Medici to persuade the Pope through his ambassador Averardo Serristori that, since Michelangelo was now very feeble, a careful watch should be kept on those who were looking after him, or helping him in his home. Vasari suggested that the Pope should make arrangements so that, in the event of his having an accident, as old men often do, all his clothes, his drawings, cartoons, models, money, and other possessions should be set down in an inventory and placed in safe-keeping for the sake of the work on St Peter's. In this way, if there were anything there concerning St Peter's or the sacristy, library, and façade of San Lorenzo, no one would make off with it, as frequently happens in such cases. In the event, these precautions proved well worth while.

Michelangelo's nephew Lionardo wanted to go to Rome the following Lent, for he guessed that his uncle had now come to the end of his life; and Michelangelo welcomed this suggestion. When, therefore, he fell ill with a slow fever he at once made Daniele write telling Lionardo that he should come. But, despite the attentions of his physician Federigo Donati and of others, his illness grew worse; and so with perfect consciousness he made his will in three sentences, leaving his soul to God, his body to the earth, and his material possessions to his nearest relations. Then he told his friends that as he died they should recall to him the sufferings of Jesus Christ. And so on 17 February, in the year 1563 according to Florentine reckoning (1564 by the Roman) at the twenty-third hour he breathed his last and went to a better life.

^{1.} Michelangelo died on 18 February 1564.

Now I shall not include here the very many epitaphs and verses in Latin and Tuscan composed by various able men in honour of Michelangelo, for they would need a volume to themselves and in any case have been quoted and published elsewhere. But I shall not omit to mention, as I end this Life, that after Michelangelo had been properly honoured, the duke then ordered that he should be entombed in Santa Croce, where he had himself expressed the wish to be buried along with his ancestors. To Michelangelo's nephew Lionardo, his Excellency gave all the marbles and variegated stones that were needed for the sepulchre, which was designed by Giorgio Vasari and carried out by Battista Lorenzi, an able sculptor, who also did the bust of Michelangelo. Three statues, representing Painting, Sculpture, and Architecture, are to adorn the tomb; and these have been allocated to Battista, to Giovanni dell'Opera, and to Valerio Cioli, Florentine sculptors. Work on the statues and the tomb is proceeding now and they will soon be finished and put in place. The cost of the tomb (not counting the marbles received from the duke) is being met by Lionardo Buonarroti; but in order not to fail in any way in honouring the memory of the great Michelangelo, his Excellency proposes to place his bust with a memorial tablet in the cathedral, where are to be found the busts and names of other distinguished Florentines.

PENGUIN 60s CLASSICS

APOLLONIUS OF RHODES · Jason and the Argonauts ARISTOPHANES · Lysistrata SAINT AUGUSTINE · Confessions of a Sinner JANE AUSTEN . The History of England HONORÉ DE BALZAC · The Atheist's Mass BASHO · Haibu GIOVANNI BOCCACCIO · Ten Tales from the Decameron JAMES BOSWELL · Meeting Dr Johnson CHARLOTTE BRONTË · Mina Laury CAO XUEQIN . The Dream of the Red Chamber THOMAS CARLYLE · On Great Men BALDESAR CASTIGLIONE · Etiquette for Renaissance Gentlemen CERVANTES · The lealous Extremaduran KATE CHOPIN . The Kiss IOSEPH CONRAD . The Secret Sharer DANTE · The First Three Circles of Hell CHARLES DARWIN . The Galapagos Islands THOMAS DE QUINCEY · The Pleasures and Pains of Opium DANIEL DEFOE · A Visitation of the Plague BERNAL DÍAZ · The Betrayal of Montezuma FYODOR DOSTOYEVSKY · The Gentle Spirit FREDERICK DOUGLASS . The Education of Frederick Douglass GEORGE ELIOT · The Lifted Veil GUSTAVE FLAUBERT · A Simple Heart BENJAMIN FRANKLIN · The Means and Manner of Obtaining Virtue EDWARD GIBBON · Reflections on the Fall of Rome CHARLOTTE PERKINS GILMAN . The Yellow Wallpaper GOETHE · Letters from Italy

HOMER · The Rage of Achilles HOMER · The Voyages of Odysseus

PENGUIN 60s CLASSICS

HENRY JAMES . The Lesson of the Master FRANZ KAFKA · The Judgement THOMAS A KEMPIS · Counsels on the Spiritual Life HEINRICH VON KLEIST . The Marquise of O-LIVY · Hannibal's Crossing of the Alps NICCOLÒ MACHIAVELLI · The Art of War SIR THOMAS MALORY . The Death of King Arthur GUY DE MAUPASSANT · Boule de Suif FRIEDRICH NIETZSCHE · Zarathustra's Discourses OVID · Orpheus in the Underworld PLATO · Phaedrus EDGAR ALLAN POE . The Murders in the Rue Morgue ARTHUR RIMBAUD · A Season in Hell IEAN-IACQUES ROUSSEAU · Meditations of a Solitary Walker ROBERT LOUIS STEVENSON · Dr Jekyll and Mr Hyde TACITUS · Nero and the Burning of Rome HENRY DAVID THOREAU · Civil Disobedience LEO TOLSTOY . The Death of Ivan Ilyich IVAN TURGENEV · Three Sketches from a Hunter's Album MARK TWAIN · The Man That Corrupted Hadleyburg GIORGIO VASARI · Lives of Three Renaissance Artists EDITH WHARTON · Souls Belated WALT WHITMAN · Song of Myself OSCAR WILDE . The Portrait of Mr W. H.

ANONYMOUS WORKS

Beowulf and Grendel Gilgamesh and Enkidu Tales of Cú Chulaind Buddha's Teachings Krishna's Dialogue on the Soul Two Viking Romances

READ MORE IN PENGUIN

For complete information about books available from Penguin and how to order them, please write to us at the appropriate address below. Please note that for copyright reasons the selection of books varies from country to country.

IN THE UNITED KINGDOM: Please write to Dept. JC, Penguin Books Ltd, FREEPOST, West Drayton, Middlesex UB7 OBR.

If you have any difficulty in obtaining a title, please send your order with the correct money, plus ten per cent for postage and packaging, to PO Box No. 11, West Drayton, Middlesex UB7 OBR.

IN THE UNITED STATES: Please write to Consumer Sales, Penguin USA, P.O. Box 999, Dept. 17109, Bergenfield, New Jersey 07621-0120. VISA and MasterCard holders call 1-800-253-6476 to order all Penguin titles.

IN CANADA: Please write to Penguin Books Canada Ltd, 10 Alcorn Avenue, Suite 300, Toronto, Ontario M4V 3B2.

IN AUSTRALIA: Please write to Penguin Books Australia Ltd, P.O. Box 257, Ringwood, Victoria 3134.

IN NEW-ZEALAND: Please write to Penguin Books (NZ) Ltd,

Private Bag 102902, North Shore Mail Centre, Auckland 10.

IN INDIA: Please write to Penguin Books India Pvt Ltd, 706 Eros Apartments, 56 Nehru Place, New Delhi 110 019.

IN THE NETHERLANDS: Please write to Penguin Books Netherlands bv, Postbus 3507, NL-1001 AH Amsterdam.

IN GERMANY: Please write to Penguin Books Deutschland GmbH, Metzlerstrasse 26, 60594 Frankfurt am Main.

IN SPAIN: Please write to Penguin Books S. A., Bravo Murillo 19, 1° B, 28015 Madrid.

IN ITALY: Please write to Penguin Italia s.rl., Via Felice Casati 20, 1–20124 Milano. IN FRANCE: Please write to Penguin France S. A., 17 rue Lejeune, F–31000 Toulouse.

IN JAPAN: Please write to Penguin Books Japan, Ishikiribashi Building, 2-5-4, Suido, Bunkyo-ku, Tokyo 112.

IN GREECE: Please write to Penguin Hellas Ltd, Dimocritou 3, GR-106 71 Athens. IN SOUTH AFRICA: Please write to Longman Penguin Southern Africa (Pty) Ltd, Private Bag X08, Bertsham 2013.